# Stone Talks

# Stone Talks

Alyson Hallett

Triarchy Press

Published in this first edition in 2019 by:
Triarchy Press
Axminster, England

info@triarchypress.net
www.triarchypress.net

A catalogue record for this book is available from the British
Library.

Print ISBN: 978-1-911193-55-5
ePub ISBN: 978-1-911193-56-2

Printed by TJ International Ltd., Padstow, Cornwall

# Contents

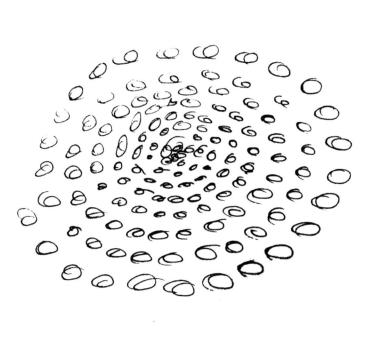

# On Kinship

## Embodied Reading

While packing for a recent trip to New York, I was disappointed to realise I didn't have room to take the book I was besotted with. Travelling with cabin baggage only, I was limited to taking books necessary for work and the one I was besotted with didn't come into this category. I moaned about this to a friend and she suggested that, without the text, I had a chance to take the book with me in a different way.

"What do you mean?" I said.

"You can embody the ideas in it", she said, "you can live and breathe them, start to understand them with the whole of your body instead of just your head."

The book in question was *Staying with the Trouble* by Donna Haraway. It contains the potent and highly relevant idea that in these times of environmental destruction we need to think about kinship and how we make relationships of kin with all things, including what she refers to as 'critters'. This not only makes sense to me, but it appeals to the child in me who sees no difficulty in talking to worms and butterflies and trees. I have my mother to thank for this. As a child I saw her greet blackbirds and sheep, cows and butterflies as warmly as any other friend or relative.

As the Boeing 737 rose into the sky, I settled into watching a documentary about Alexander McQueen closely followed by 'The Children Act', based on Ian McEwan's novel of the same name. I'd feasted on gnocchi with spinach and spicy tomato sauce, downed a couple of drinks and was now feeling sleepy.

As soon as I closed my eyes, my friend was there again, nudging me, reminding me that without my beloved book I had agreed to embody the ideas in it instead.

What did that mean? Embody the ideas in a book? Osip Mandelstam, in *Journey to Armenia*, mentions the physiology of reading. "It is a rich, inexhaustible, and, it would seem, forbidden theme." Instead of entering into this forbidden theme, he changes direction after this sentence. Which left me wondering how we go about bringing what we have read into our lives, translating the words that have stimulated our imaginations into our bodies and the way we live. So that a book is not just something we read and then cast away, but something we absorb, digest and allow to viscerally affect us.

In *To Kill a Mockingbird*, there is the suggestion that reading can teach us to walk in other people's shoes. Empathy, or sympathy, is the route that the imagination takes when it engages with lives that are different to its own. In my case, however, I was wanting to dive into kinship – and for a while it seemed as if there was no way on earth I was going to be doing that in an aeroplane.

Something began to creep into me. I wasn't on earth. I was in a metal pod that was hurtling through the sky at around six hundred miles an hour. What made this possible? Fuel. And where did fuel come from? The decomposed bodies of plankton, plants and animals whose liquidation created that beautiful, black viscous gold we call oil. The only reason I was able to hurtle through the sky was because of the countless critters who had lived and died and then been subjected to a process of transformation for more than one hundred and fifty million years.

I closed my eyes. Took a deep breath. Sent myself down, down into the ground, all the way down to where the miniscule plants and creatures had long since ceased to be

identifiable as individual entities. I imagined myself into their lives before they died. Microscopic, transparent, drifting. Dinosaurs were walking on the land and human beings were not even a twinkle in a lizard's eye. I went into the world of the critters, their planet, their ocean where life was possible and where death was possible too. When we died, our bodies fell to the sea bed. Body upon body piled up. So many bodies it was a mass grave of epic proportions.

Next, mud and sand fell on top of us. One layer led to another layer, each successive layer heavier than the last. Layer upon layer pressing down on us. Then more layers on top of that. Until there were so many layers that I lost track of the one I started with. Heat and pressure increased. The layers so heavy we broke down and began to merge, to transform.

This was a curious thing to do. Transporting myself into the creatures whose lives and deaths created the fuel that was catapulting me through the atmosphere. As my body travelled inside a metal tube, I travelled inside my body and into the imagined bodies of tiny creatures. These creatures were and are my kin. Without them, flight is not possible. Without them, I would not be flying from London to New York.

It seems absurd to countenance that plankton which lived one hundred and fifty million years ago are now responsible for my metaphoric wings. Not forgetting the processes of extracting oil, refinement, the developments of design and engineering, I burrowed into an intimacy that would have passed me by if I'd been able to bring Haraway's book with me because I would have kept on reading without pausing to bring the ideas out of the book and into the body of my imagination.

Perhaps this is why Mandelstam called the physiology of reading a forbidden theme. It isn't easy to do. I'm not even sure it's pleasurable. It has changed my perception of the

world though. I have had to carve out a space inside myself to take in a bigger reality than I had previously understood. Instead of oil being an idea, a black thing that's drilled out of the earth, I now had a feeling for the critters the oil was made from. To imagine something is to bring it not only into our minds but into our bodies. The critters were inside me now. I had felt my way into their lives and, as a result, they had come into mine.

The mystical dictum *as above so below* took on a different resonance. I was starting to see that I was only in the sky because of what had been hidden under the ground. I thanked the critters. I made room for them in my heart, for the sand and mud and rocks that had participated in their transformation. I was discovering that kinship, if it was going to extend beyond an idea in a book, required time and imaginative energy, and from this an awareness that stitched me to the ancient lives of critters as surely as two sides of material are stitched together in a seam. Inseparable then, and along with that an immense gratitude.

I opened my eyes. The lights in the cabin were dimmed. I wasn't sleepy any more. I scrolled through the menu and started to watch another film.

## Embodied Walking

Entering a country where major institutions were on lock down because its President wanted money to build a wall between the USA and Mexico also required skills I had rarely used before. An example of this was on the day when I decided to visit the National Museum of the American Indian, which is situated at the southernmost point of Manhattan where boats leave to cross over to Ellis Island and the Statue of Liberty.

I arrived around eleven o'clock, looking forward to a museum that I hadn't visited before. I bounded up the steps but half way up there was a freestanding notice:

All Smithsonian museums and the National Zoo are closed today due to the government shutdown.

It felt like walking into a glass wall – I could see the museum in front of me but I wasn't able to go into it. What I saw and what I was being told didn't match and this meant it was hard to believe. I experienced something similar to this when a bicycle that I'd had for years was stolen. I'd locked it with a D lock to a bike rack near the Odeon in Bristol city centre and gone off to do some shopping. When I came back, the bicycle wasn't there but for ten minutes at least I couldn't believe that it wasn't there. I looked around and checked that it wasn't nearby. Then I stared at the empty bike rack and tried to take in what I was seeing. It seemed impossible that it had gone, that its substance was no longer where I had left it. Someone I knew passed by and asked if I was all right. I told them what had happened and they ushered me into a café and bought me a coffee.

Still in a state of disbelief that a national museum could be closed due to a government shutdown, I noticed an open door at the bottom to the right of the steps – skipped down and went in. Three museum guards were skulking around a table. They were surprised to see me, but I was glad to see them as I thought they might be able to let me in.

"Is the museum really closed?" I said.

The guard nearest me nodded. "Yes mam."

I asked them how they felt about this and about having to work without being paid.

"We're not at liberty to comment Mam."

I sidled out and wondered what to do. The Holocaust Museum was nearby and so I set off along the sunny street, the Hudson glistening on my left, swathes of tourists lining up to buy tickets that would let them get on the boat that would take them closer to one of the most iconic symbols of liberty. The irony of this did not pass me by.

I decided not to visit the exhibitions in the museum and headed instead for the café after a long chat with a retired lawyer who was sitting in the entrance to the Holocaust Museum. We talked of absurdities and fear, both in the USA with regard to the current President and in the UK, with regard to the chaos of Brexit and the rise of the far right in Europe. Here I am, in these times, I thought, these turbulent and increasingly intolerant times.

In the café I ordered coffee and poppy seed cake. The cake was warm and one of the most delicious things I have tasted. Outside the plate glass window stood nineteen stones whose cores had been hollowed with fire and replaced with soil so trees could grow out of them. It was the work of UK artist Andy Goldsworthy, made as a living memorial to the Holocaust.

As I sat and wondered what I might do for the rest of the day, I remembered reading that the building housing the National Museum of the American Indian was the Custom House. Before income tax was invented, up to 80 percent of the money that financed America's federal government came from the duty levied on imported goods that came through the Port of New York. I also remembered that the Museum sat on the original Algonquin trading ground at the foot of the Wiechquaekeck Trail,

> a centuries-old trade route whose original path
> has evolved into today's Broadway.

If I couldn't go into the museum, I'd find another way of exploring the heritage of the first peoples of this land.

I walked back to the Custom House. The sun was shining and there wasn't a cloud in the sky. It was early January and the breeze was warm. I stood by the plaque and read it again, somewhat amazed at my own amazement that before Broadway there was already a trade route pulsing across the island.

I decided to walk a mile of Broadway with my brain in my feet. I wanted to send my awareness down into my toes, my arches, my soles. I wanted to walk on the tarmac and walk through it at the same time. To go under what was on the surface and meet the old route that lay underneath. My mile-long walk was to be a homage to the first peoples, to the lives they led here, to the brutalities that were visited upon them and are still being visited upon them.

I started to walk along Broadway but it was no longer Broadway. The tall buildings disappeared. I was walking on the Wiechquaekeck Trail, a guest, an interloper, an intruder. There was a strong pulse, an energetic line that no doubt informed the great, loud blaze that is today's Broadway. As I walked I realised that this was another way of making kinship, this time with a past that was all too possible to ignore.

Later that day, I visited New York Public Library. Written on the wall in large letters is the following:

> On the diffusion of education
> among the people
> rest the preservation
> and perpetuation
> of our free institutions.

Is an institution still free when it is on shutdown? Are people still free when their histories are concreted over, when the lands that were taken from them are still not recognised as stolen land? What is this freedom and how, in these troubled times, do we do what needs to be done to preserve democracy for all people? I have no easy answers but sometimes we need to sit with the questions for a while to wait and see what they deliver. In this way, we find the courage to open our hearts and remember that making kinship is always better than building walls, whether those walls are real or metaphorical.

# Stone Talks

A version of this talk was first delivered as a keynote lecture at the 'In Other Tongues' symposium, organised by Richard Povall of artdotearth, Dartington, June 2017.

# Introduction

Thank you for inviting me here today to take part in these conversations, these collaborations and explorations.

Earth is made of stones and rock. They are our bedrock, our foundation; stones form the body of the planet we live on, the planet that shoulders us, that bears our weight and our lives. And all the while, above our heads and all around us in space, planets orbit the sun and meteors hurtle from here to there. Since we've been on this planet, as humans, we've paid attention to the patterns of stars and the spirits that live in stones. Lucy Lippard writes,

> Stones touch human beings because they suggest immortality, because they have so patently *survived*. Virtually every culture we know has attributed to pebbles and stones, rocks and boulders, magical powers of intense energy, luck, fertility, and healing.

In this sense, when we are born, and before we are born, conversations are already taking place with the rocks and stones beneath our feet and above our heads.

This talk explores some of the ways that I work with stones. It has been composed by taking many bare-footed walks around the meadow behind the house where I live in Somerset. Often I don't know what my thoughts are until I write them down. For me, writing is a process of discovery, a way of working myself into territories where I don't know what it is I want to say until I've written it. Perhaps this is why I spend so much time reading and writing poetry. As Hélène Cixous notes in *Coming to Writing*:

> I call poet any writing being who sets out on this path, in quest of what I call the second innocence, the one that comes after knowing, the one that no longer knows, the one that knows how not to know.

I spend a lot of time not knowing what I'm doing. It seems to be the most honest place to start working from. An inclusive place. A deeply collaborative place. When I don't know what I'm doing, I wait for a prompt. It can come in a dream. From a stone. It can rise up from a part of my body. It can be a thought arrowing in as I turn a corner in the meadow.

The talk is divided into 5 chapters. Each one explores stones and my relationships with them. I'm going to talk about work that's in the public domain as well as work that's remained private until now. I want to let you see different sides of my practice. How one thing informs another.

The talk isn't trying to get to anywhere in particular. It's more of a circumambulation, a winding around things and looking at them from different angles. Two threads hold it together. One is the continual and ongoing need for enough time and space to enter the place of Not Knowing. The other is a willingness to do things that often seem foolish and which are prompted by voices that do not come from my conscious mind.

W.G. Sebald suggests that:

> ...work gets done in the same way in which, say, a dog runs through a field. If you look at a dog following the advice of his nose, he traverses a patch of land in a completely unplottable manner. And he invariably finds what he's looking for.

I suspect that when I work I am listening to my animal self, my uncivilised self, the lizard that still inhabits the core of my brain. I am like the dog following its nose, only sometimes I'm following my ears or my eyes or my elbow or my feet. Other times I am listening to the voices of the dead. This is something I have done since I was a child. The voices in the wind. The voices in stones. If I think about this too much, it's disturbing. If I don't think too much, it's just my life.

# Chapter 1

## Pebble No Bigger Than My Thumbnail

The first time I was pulled into the language of stones I was 19. At Holcombe Beach, Norfolk. I was out for a day by the sea with friends from university. After much talking and larking around, I drifted away from the others so that I could stare out to sea and lose myself in the long line of the horizon. It's like a door sometimes that line, a door that's been left ajar, that invites you to enter another world. When I came back from my reverie, I looked at the pebbles on the beach and picked one up. A tiny pebble, no bigger than my thumbnail. It was a mottled brown colour and there was an off-centre, raised white quartz cross on it. I stared at this cross. One vertical line, one horizontal line. A place in the middle where the two lines intersected. *One day you must explore what this cross means*, the pebble said. Just like that. As clearly as I'm speaking to you now.

A beach is composed of millions of pebbles, and yet it seems to be easy for each one of us to zoom in to the one that attracts us. I sometimes wonder if the pebble is waiting to be found, to be singled out, as much as we are hoping to find it.

I have yet to meet someone who doesn't bring stones home from a beach. Every child, every adult – even my friends who are the kings of minimalism have room for a few pebbles in their home. These stones live with us. They are our constant companions who often fade into the background and become dusty and forgotten.

One friend, when she was emigrating to Venezuela at the age of seven, took her suitcase to the beach and filled it with

pebbles. Another friend's son bonded with a particularly large pebble and insisted he take it everywhere with him. To Pizza Express. To friend's parties. To bed. When she asked him why, he looked at her and frowned. "Can't you feel the fizzles in it?" he said, as if it was the most obvious thing in the world to feel fizzles in a stone.

I tucked the tiny pebble into my pocket and took it home. Four years later, after finishing a job in mental health, I started looking for voluntary work. Jean Clarke, a counsellor, suggested the Iona Community on the Isle of Iona in Scotland. I had never heard of Iona. Jean told me it was a place with ancient Celtic crosses. The place where Saint Columba landed in a coracle and brought Christianity to Britain. As she spoke to me, the pebble with a cross on it, which I had completely forgotten about, jumped into my mind and said, *Yes. Go there. This is the place you need to be.*

All the rest of my life, perhaps, has been based upon finding this pebble and the direction I took because of it. When I think of it now, I think of finding this pebble as an echo from my future. My life was steered by these moments, these findings, these decisions. The cross led me to ask: what is horizontal, what is vertical, how do they intersect, what is time? And in turn these questions came to infuse my work and life.

I went to the Isle of Iona for 6 weeks and stayed for 18 months. I became a housekeeper in an Abbey; met people from all over the world; became a dj for the ceilidhs and discos we had each week in the village hall. I began to learn the ethos of how work, worship and play are woven together. And all because of finding that pebble on Holcombe beach. Being found by that pebble on Holcombe beach. Encountering a moment when we came into each other's presence and a new thought was born.

I'd like to end this chapter with a poem by the Mexican poet Jorge Esquinca.

**The Water and the Stone**

There is a stone at the bottom of the drinking water. A small, polished, almost white stone. In the night water and stone exchange rare substances, habits, silences. The water then acquires a darker flavour and seems to quieten, as if distracted, a little blurred, thoughtful even. A subtle, bluish brilliance emanates from the stone like the tiny flame of alcohol. Observe with attention and you'll see the stone stir, as if waking from its mineral lethargy, from its docile subterranean sleep. And for a moment it beats meticulously like the heart of a bird. At dawn the poet takes the stone out of the drinking water. Without much ceremony he places it under his tongue. He does not drink the water, he leaves it by the window in case God should want to ease his thirst.

(trns. Alyson Hallett and Mercedes Núñez)

# Chapter 2

## In The Beginning Was The Boulder

It's August, 2001. Six months since my nan, Hilda Hallett, died. I loved my nan. She lived in a terraced, red-bricked house in Bridgwater, Somerset. We used to watch the wrestling on a Saturday afternoon in front of a gas fire and eat the cake she had baked for my visit. Chocolate cake, coffee cake, cherry cake. All of them delicious. Her house was the centre of our lives. A plastic curtain swished in the hall to deter flies from coming in during the summer months when the front door was left wide open. My nan polished the brass strip at the entrance to her house, she also swept her bit of pavement, and sometimes the stretch of road outside her door. With seven children in one small house, you value the way private space spills into public space. The expansion this gives. The way private and public are stitched together.

I had twenty-six aunts and uncles and fifty-seven cousins: but when my nan died, she left a gash in our lives the depth and height of Cheddar gorge.

Six months after we took her body to the crematorium in Taunton, my nan appeared in a dream. *You need to go and climb Cader Idris*, she said. When I woke up, her voice was still ringing in my head. I knew that Cader Idris was a mountain in the Snowdonia range in North Wales, but I also knew that I didn't climb mountains, I was busy and had no intention of doing what a voice in a dream had told me to do. I decided to ignore it, to assume that it would just dissolve, as most dreams do.

How wrong was I?

Night and day nan's voice haunted me. It seeped into everything. It was ink in water. Sugar in coffee. The buzz of a trapped fly. *Go and climb Cader Idris. Go and climb Cader Idris.* Eventually I cancelled work, hired a car, threw a tent and sleeping bag in the boot and set off for Wales. On the long drive there, my mind was febrile. I had no idea what I was doing. Was I mad to be following a voice in a dream? Had I lost the plot altogether? If I'd had this quote from Anaïs Nin to hand, I might have been a bit more gracious in my surrender. She writes:

> The unknown was my compass. The unknown was my encyclopedia. The unnamed was my science and progress.

I pitched my tent by a river. Slept badly. Woke early and laced up my boots. Before entering the foothills, I lit a candle and incense and asked for permission to climb. Rituals are important to me. They ground me. Centre me. Allow me to knock on a door and begin lacing together different levels of reality. As the poet Homer notes, all gods and goddesses love to come down and feast on perfumed incense smoke. That morning at the base of Cader Idris, I was almost hoping to hear the word *no*, so that I could pack everything up, go home and return to a way of being that I thought of as normal. But no didn't come. And so I set off, up the stony path, up the steep and stony path that wound its way to the summit.

I was out of my mind. I was in it too. I was a confusion of thoughts walking a stony path. Walking into moss, into the tumbling stream, into the gnarled bark of old oaks that fringed the stream. In the foothills of Cader Idris, I lay down on a low-lying branch of an oak and rested for a while. Several months later, I wrote the following poem:

### Foothills Girl, Cader Idris

I'm a dedicated foothills girl
dreaming where the stream runs fast
and trees screech towards the sky.

At home in the crook of an oak
watching moss-skinned stones
while the mountain climbs behind me.

No-one else stops here but me, seduced
by low-life greening and the perfume of pine.
Nothing here is mine and I'm madly in love –

thinking of proposing marriage to a mountain
if you're allowed to do such a thing.
Love, honour and obey – I'd stay faithful

to this rock more easily than any human.
We'd live out our mutual passion day by voluptuous day
until the floods came or we both melted with the sun.

I continued to climb the mountain. Halfway up I came across a boulder by the side of the path and stopped to stare at it. It looked out of place, as if it didn't belong. I saw a man approaching from a distance. As he came nearer, he said hello then stopped to talk. He asked why I was looking at the boulder. I'm wondering where it came from, I said. It's an erratic, he said. A what? I said. An erratic. A stone that broke away from its motherbed and travelled inside a glacier. Really? I said. The man nodded, then told me he was a geologist.

I stared at the boulder – it had travelled hundreds of miles across the country, the glacier making gorges and valleys as it sawed through the ground with its icy prow. And all the

while the little boulder inside, like a baby waiting for the sun to warm up, for enough heat to melt the ice and release it.

It took a moment or two for the geologist's words to sink in. Stones moved. They migrated from one place to another. They did not stop for borders or boundaries. *Solid as a rock, written in stone* – suddenly everything I knew about stones flipped on its head. They weren't just fixed in one place; they were travellers.

And that was it. The moment when a seed was planted and took root in the disturbed soil of my mind. I continued to the top of the mountain, said goodbye to my nan as the mist curled around us and black mountain crows made their strange and eerie caws.

Over the following months, I became obsessed with travelling stones. With the different ways they moved. Erratics. Ballast in the empty hold of a ship. Pebbles picked up from beaches and taken home. Emeralds, rubies, opals worn around our necks and on our fingers. The way plesiosaurs swallowed stones to stop them from rising when they swam underwater. Animals and birds that swallow stones to aid digestion – chickens, crocodiles, ostriches, penguins, seals, whales. Stones stuck in the soles of our shoes. Gravel escaping from front yards.

I applied for an Arts Council Grant to explore the migration habits of stones. I never for one second thought they'd go for it, which meant I had great fun applying. My idea was to create a project that allowed me to research how stones moved and then make a piece of public art. To do this, I'd collaborate with a stone carver and site a stone with words carved into it in a public place. A year before, I'd been commissioned to write a poem that was then carved into a pavement in the city of Bath. I loved doing this: seeing words inhabit material, the way they became three-dimensional, the

difference this made, how they achieved a different frequency when they were as much a part of a place as a pavement or a lamp-post.

I grew up in the town of Street, home of Clarks shoes. The Clark family were Quakers and philanthropists. Just next to the entrance to the shoe factory, which was situated on the High Street, was a Henry Moore sculpture: 'Sheep Piece'. Every day when I walked up and down the High Street to school, I passed this sculpture. From an early age, it was obvious to me that art belonged in the heart of a community. The most beautiful things did not need to be shut away, they could be located in places where everyone could see them: factory workers, children walking to school, people driving by. Art lived in the open air, it was democratic, it was as essential to daily existence as a potato or an apple.

When the grant application form asked about the demand for the work I wanted to make, I wrote a long philosophical essay about how it was a mistake to think demand could be established before work was made. I talked about creating work that would be given as a gift, quoted the anthropologist Marcel Mauss, argued that my work would be a gift to a planet that had already given me the biggest gift of all, the ground upon which I live my life.

As a mirror to their bureaucracy, I also made an accompanying booklet (these were the days when applications were made on paper) detailing how they should read my application and at which point they should reference the relevant notes and attachments. I believed they were never going to fund me and so I had nothing to lose. In response to the questions about audience, I argued that my audience couldn't really be counted if I made work that was sited out of doors as it included insects, birds, breezes, people, sunshine, the moon, thunder, lightning. How do you count the rain? I asked. In

response to a question about duration, I suggested that if I had words carved into slate the probable length of the piece of work would be around three hundred years.

I've always been a dreamer, an idealist. And, all those years ago, this was something the Arts Council valued. They said yes and gave me an Individual Artist's Award that was nearly enough to live on for a year.

What began with a walk up a mountain and a meeting with an erratic and a geologist has turned into an eighteen-year project – and it's still going. In the first funded year, I did lots of research and then created one thing, a single migrating stone. I collaborated with the sculptor/letter carver Alec Peever. We travelled to a quarry in North Wales together, chose a piece of slate, and he then carved the first line of one of my poems into it.

I wanted to site the stone in Leigh Woods, Bristol. To make this happen, I wrote a proposal and approached the wardens of the woods, essentially asking them if they'd give a home to a migrating stone. The underlying themes of this proposal, and the whole project, are ones of hospitality, greeting a stranger and generosity of spirit. To my surprise and delight, the wardens said they'd love to have a migrating stone in the woods. It's still there, just off the purple path surrounded by three yew trees. There's no plaque, nothing to say what the work is or who it's by. I wanted it to intrigue people, to maybe get them to ask a question or just ponder what it might mean, a stone in the woods with the words "And stones moved silently across the world" carved into it.

After we launched this first stone with a party and a group of people walking through the woods at dusk to welcome it to its new home, I thought I'd finished with migrating stones. The stones themselves, though, seemed to have another idea. Next, I was invited to take a stone to a retreat centre on a

mountain in Massachusetts. After informing customs that I was bringing a stone into the country, I took the second migrating stone to the USA in September 2004. I travelled via New York because I wanted to walk around the city with the stone in my suitcase as an act of peace and awareness in a city that had so recently been devastated. This walk with a stone was a performance and the audience was an unsuspecting sky and an unsuspecting city.

While I was at the retreat centre, I dreamed that I should take a stone to Koonawarra. I looked at an atlas but couldn't find anywhere with that name. I was relieved. It's just a dream, I thought. When I returned to the UK, I put the name into Google out of curiosity and it informed me that Koonawarra was not only a place in Australia south of Woollongong, but that in Aboriginal language it meant *high point of land with smooth white stones*.

Shortly before leaving for Australia with the third migrating stone I was approached by Sarah Blunt from BBC Radio 4 with an invitation to create an audio-diary about my trip with a stone. I was delighted to have the opportunity to record my journey and interview people along the way. It was a fantastic experience and totally unexpected – as was being labelled completely mad by a Radio 4 listener who complained about my work when the diary was broadcast as part of a series on Nature (not everyone considers a woman and a stone to be a part of nature).

Perhaps one of the biggest surprises came when I was invited to the Geological Society in London to read poems and talk about my work during a day on poetry and stones. I never imagined the day might come when I would step into the hallowed heart of geological science to talk about my work with stones and dreams. When I arrived in the building I was met by a man who took both my hands in his and said how

pleased he was to meet me. What a warm greeting, I thought. He then went on to say that in his opinion, science could take us so far in understanding stones but that we needed poets to take us further. Imagine my surprise a little while later when Bryan Lovell, the president of the Geological Society, stood up to address the audience and I saw the man who had greeted me when I arrived.

And on it goes. 'The Migration Habits of Stones' has continued in a haphazard, unpredictable, slow and instinctive way to where I am now. Five stones have been sited in different places around the world. The first four have the same words carved into them: And stones moved silently across the world. For the fifth stone, I asked my friend Andrea Dates to translate this line into Spanish as the stone was going to Los Angeles. We made a radical decision to change 'move' to 'migrate' as a way of reflecting the mass migrations of people happening in the world: *migran en silencio las piedras por el mondo.*

I'd like to finish this chapter with a poem that I wrote at the very beginning of the migrating stones project, and whose first line has been carved into all five of the migrating stones.

### 'And stones moved silently...'

> *"The mode of perceiving nature, under the rule of private property and money is a real contempt for, and practical degradation of, nature."*
>
> Karl Marx

And stones moved silently across the world
hurled into an empty ship's weightless hold
folded into a glacier's freezing mound,
quick-pocketed by tourists and children
with an eye for things shiny and round.

Bound for other lands stones sailed without papers
traffickers in freedom crossing borders
with no regard for guards, guard dogs
or guns. Dumb as the tongueless
their acts alone sounded the long, low cry.

Each stone carried centuries of weight
and meaning. Ballast from Bristol belly-up
in New York's East river, erratics paused
on the slopes of Cader Idris, fingers of quartz
startling my window sill – all of them travelled

from the place where they began, where we might
have said they belonged. Migrating past line,
border, boundary, their movements a constellation
of questions; where is home, what is home,
and who in this world can claim land as their own?

# Chapter 3

## The Body As A Site Of Intelligence:
## The Body As A Site of Ignorance

Taos, New Mexico. I'm staying at the Pink Adobe Motel for a week and have made friends with a sculptor called Daryl. Every evening we sit on the porch talking and staring at turkey vultures squatting in a huge cottonwood tree. The ground beneath the tree is bare because their droppings are so acidic. One night, Daryl wakes me at three in the morning and we walk through the town and out along empty roads. We go further and further into the darkness until we come to a place that's a long way from any streetlights and lie down on our backs in the middle of the road.

We stare at the sky. It is no longer just the sky: there's a meteor shower exploding all around us. Bright, burning rocks are flying everywhere, as if they're birds, as if all the stones in our universe have wings and can fly. I hold my breath then remember to breathe again. My blood fizzes. What I see in the sky sinks deep into my body, as if there's room inside for fireworks, for this great display of travelling light.

The next day, I visit Jacky's Pawn Store. It's on the edge of town, close to Taos Pueblo which has been inhabited for more than a thousand years and is now protected by Unesco. Jacky's Pawn Store is where Indians used to go to exchange things for money. I find a large piece of turquoise with a twisted metal loop at the top which means it can be worn as a necklace. It's an odd-shaped piece of stone, irregular, bumpy. I buy it thinking it's a good souvenir, that when I get home I'll thread a chain through the metal loop and wear it around my neck.

I feel very pleased with myself and with my authentic souvenir.

For many years I have loved the stories about Sitting Bull and the writings of Chief Seattle. Now I am closer to them. I have a piece of turquoise from Taos and I am going to wear it around my neck.

I take the stone home with me, thread a chain through the metal loop. Each time I put it on though, it doesn't feel right, doesn't sit well on me. It looks odd and it feels odd. Next, I try putting it on a shelf. It looks forlorn. Wrong. Just as it didn't feel right around my neck, it is also not right sitting on a shelf and so I wonder about turning it into a bracelet – whether this will solve the problem of the difficult turquoise stone.

I am nothing if not persistent. For eleven years, I wear this stone, look at it, keep it in a box and forget it, then try to wear it again. What was it Beckett said:

> Fail. Fail again. Fail better.

If I had been more aware, I would have realised that my failure was reaching epic heights. But I wasn't aware. I was determined to find a way of having this piece of turquoise in my life, of finding a way of being comfortable with it.

Leslie Marmon Silko, a native American author, writes:

> In the view of the old-time people, we are all sisters and brothers because the Mother Creator made all of us – all colors and sizes. We are sisters and brothers, clanspeople of all the living beings around us. The plants, the birds, fish, clouds, water, even the clay – they are all related to us. All things, even rocks and water, have spirit and being.

Francis of Assisi talked of Brother Sun and Sister Moon. As a girl, growing up, my mother taught me to curtsey to the new moon. It was considered bad luck not to do this. The luck of our days was tied to the moon, to showing a rock in the sky respect. My mother was the daughter of a farm labourer in Chedzoy, Somerset and their livelihoods depended upon the land and the things that fed the land. My mother grew up sharing a bed with three others. The only place she was alone was in the fields and even then she wasn't alone. So many herons, grasses, clouds. In *The Plumed Serpent*, D. H. Lawrence writes about a hired farm labourer:

> [he] never felt he was working for a master. It was the land he worked for. Somewhere inside himself he felt that the land was his, and he belonged in a measure to it.

This reverses the idea that labourers work for land owners. In this reality, the land is the master and people and land belong to each other in a relationship that is mutual.

After my father died, he appeared to me the night before his funeral. I was surprised to see him. I was busy polishing my shoes and ironing a pair of trousers. He wanted to give me something. To hand me a baton. To give me a quality he admired and that I found hard to acquire with any consistency.

My father wanted to pass on to me his love of obedience.

I had been a punk in my teens and twenties. Self-employed nearly all my life. I liked to rebel, to break rules – what was I going to do with obedience?

The following weeks blurred into the rituals of a funeral and clearing out my father's flat. One day, I put the urn containing

his ashes into a rucksack, slung it on my back and took a walk around Bridgwater. We walked in a figure of 8 – past the house in Camden Road where he was born, along the canal, the river Parrett, walking past mud and reeds, past all the places we'd been together. And then came the scattering, in late July, in a field in the Quantocks. He didn't want a stone. Didn't want a memorial of any kind.

At some point during this blurry, hazy time, I remembered the baton he'd handed to me. This is it, I thought, the point where I give up my hard-won independence and do as I am told. After a few days of worrying, I looked obedience up in the dictionary and searched for the etymological root. This always comforts me. It's a bit like finding the ground under a word, digging down and seeing what its dirty, sappy origin might be. Borges reminds us that Chesterton sees the origins of language as having been:

> ...evolved through time, through a long time, by peasants, by fishermen, by hunters, by riders. It did not come from the libraries, it came from the fields, from the sea, from the rivers, from night, from the dawn.

The etymological root always brings us back to an earthy awareness of where words come from and it was no different with obedience.

*Ob* – to

*Audire* – to listen.

Obedience, in its original sense, means to listen.

Bingo.

A penny drops.

Listening is precisely what I hadn't been doing with the piece of turquoise that I'd bought in Jacky's Pawn Store in Taos, New Mexico. I'd refused to listen to it. Instead, I'd spent eleven years failing at being able to wear it or situate it anywhere in my life. Finally, finally, after my father died and I began to sit down with obedience, I got it. Finally I was able to really listen to what was going on with me and the stone.

The stone didn't feel right because it wasn't right.

There was nothing right about this piece of turquoise being in my possession.

I stopped trying to make it all right.

Instead, finally, I was obedient to the stone.

I googled the Pueblo in Taos and found an email address. Wrote to them and explained that I had bought a large piece of turquoise from Jacky's Pawn Store eleven years previously and that it had never felt right having it in my possession. I said I wanted to return the stone and asked if they could help me find a way of doing this.

On the 8th of July, 2016, they wrote back:

> We would be delighted to accept the turquoise piece you have purchased. We will do the proper procedures of the turquoise and return it back to earth.

Imagine how I felt. The piece of turquoise that I had bought eleven years ago was finally going home. It was going to be given the proper procedures and returned to earth. I wrapped the stone in a piece of burgundy suede, blanketed it in bubble wrap and posted it.

For eleven years I failed to listen to the discomfort I felt when I was around this stone. For eleven years, I failed to listen. It

was a good failure. A long failure. It wasn't until my father died, until he'd handed me the baton of obedience, that I listened to the stone and accepted it as it was.

I'd like to finish this chapter with a poem from my second collection, *Suddenly Everything*. To see the film/song of this poem (film: Julia Giles, song: Chris Hardy) please visit Youtube.

### Conversation with a Pebble

Here's what I've been wondering.
If fire hides in wood
what hides in stone?

Pebble sits in my hand
like an egg
that wants to hatch.

I don't know how long
it will take,
how long its incubation.

My time is slow,
pebble says. Slower
than you can imagine.

I kiss it and watch
the moisture from my lips
sink in.

That's what I'm hiding,
it says. Water. The tiniest
rivers and seas and lakes.

Ideas of what water
can be. I am hiding
memory, it says.

# Chapter 4

## A Field, A Stone, A Grief

Midford Valley, Somerset.

This chapter documents a stone circle/spiral that I made in a field near to where I live shortly after my dad died. The text is taken from a journal I kept while making it. It's the first time this work has been shown or talked about. The stones are now overgrown and the spiral can no longer be seen.

**19/7/15**

Scattered dad's ashes yesterday.

Today, inconsolable.

Nothing works. I send a friend a text suggesting we meet. She has no signal and doesn't receive it.

I go to church for a service at 11 (I want to sing) only to find out that it began at 9.30 and ended at 10.30.

I put a dvd in the dvd player and even after pressing all the available buttons can't get an image on the TV screen.

I go to the bottom of the garden. Into the yurt. Lie down and cry. Above, there's a round window, a tree-fringed sky. It makes me think about a wheel. There are no spokes in the centre, only spokes radiating out. Like the sun's rays. I wonder if this is what happens when we die. If the wheel that

used to turn and rely upon the inner spokes to hold it together now only has rays/spokes that radiate out from the circumference of the circle.

I fall into a deep and dreamless sleep.

Around 6 I go for a walk. Down the hill and through the field to a copse of beech trees that I've stared at from across the valley since I moved here. Good mossy roots. I sit in their towering magic and stare up at the green ceiling above.

Then on, into another field speckled with wild, yellow flowers. An oak tree on my left. Youngish. Maybe 50 years old. I walk past. Soon after I turn around and come back. Breathe. Raise hands up and out into a cruciform V. There's something lovely about making this shape in a field.

Back to the oak. I am always happiest to see an oak. Beneath this one, there's a little pile of stones. I saw it when I walked by earlier but didn't think about it much. Now I stop and look. I wonder who put these stones here in a small, imperfect circle. I decide to add to it. Start looking for stones. Find one or two then one with a fossil. Wing of fish. Perhaps a flying fish. Soon I realise there are hundreds of stones at the edge of the field. The circle increases, regularly, then irregularly. It's more of an oval than a circle.

I decide to come back tomorrow. This will be my summer project.

How did it appear? I don't know.

I had a terrible day, I went for a walk.

I'll build it as big as I can. For now it will be my secret. More potent that way.

I'll come as often as I can at different times of night and day and build.

To do the work I do, the sacred connecting, I have to have days deeply alone where my own company appalls me.

Something gives way.

I start to listen again.

I am a maker. The meaning of 'poesis' is maker. Just this, today. Making a stone circle.

**20/7/15**

Slightly misty morning.

Go back to take photos and increase the circle, make it bigger.

Stones are a gestural language

A language without words

Like music

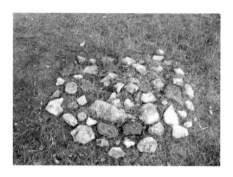

Moving these stones into a circle is a gesture, a way of saying something. A way of being with grief when I don't know how to use words. So I work with these stones instead. These silent stones in a field that I'm moving into a circle beneath an oak tree. It's mindless work, absorbing. Empty headed. The decision of whether to go here or there, take this stone or that.

One empty condom packet. This must be a great place to make love.

Cowpats.

Lots of fallen beech nut shells crunching underfoot.

It's hard to make a perfect or regular circle. And so I continue with the irregular circle. Which stone goes where, which side to increase, standing back and looking at the whole.

An interesting thing: the circle looks completely different from each angle. I look at it from the north and it appears to be nearly circular. I look from the west and it looks like an egg.

I found a fossil in one of the stones yesterday.

Today I found another.

These stones are oolitic limestone.

I'd forgotten how much I love working with stones. They take me into another dimension. They take me into a place for which I have no name and no words.

## 29/7/15. 6.30 pm. Sunny

I go to the stones at 6.30 after a week away in London. Bright sun after a cold day and rain showers.

There's a feeling of relief, or release, when I walk across the field towards the copse of beech trees.

I'm worried that the stones may be scattered – that the circle I've been building will have been destroyed. Then I think I'll make it again if that's happened.

There's deep pleasure in doing work that no-one else knows about. It's potent. Undiscussed. Undiluted. There's no permission involved, no money, no asking anyone what they think.

One day I walked into a field and saw a few stones gathered beneath a tree. And from there, a larger circle has grown.

It couldn't be more simple. I feel as if the idea was there in the field already, waiting to be found.

\*

The stones are still there.

It's a strange circle – irregular, mis-shaped, eye-shaped from a certain angle.

I begin gathering stones and adding them. I think about bringing string and checking that I'm making a more-or-less good circle.

Then I remember the Full Moon pot in the British Museum –
the one I go to see again and again in the Korean section – the
intentional imperfection of it, the lop-sidedness, the tilt and
lean, the irregular lip – and this so that there's no insult to
god, so that everyone can see it's hand made.

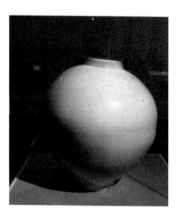

I relax. I'll enjoy whatever circle I'm able to make.

Also aware that it seems to have more than 3 dimensions – as
if what I can see above ground somehow carries on
underground.

I worked with mainly larger stones today.

A clearer circumference/boundary appears.

A stripe of sun cuts across the yellow-flowered field.

**Friday 31/7/15. 10 am. Bright sun.**

Up the hill to the stones.

I sit with my back against the oak tree for a good long while.

A lesser-spotted woodpecker appears on a tree nearby and goes about is pecking work.

Sit here for long enough and all things will come. At least, that's how it feels.

Quiet.

Not thinking anything in particular.

Begin collecting stones.

After the last visit, a distinct edge has appeared and the circle is now moving into a spiral.

Interesting to see how this has evolved.

In the beginning, I settled stones on the ground at different places on the circumference of the circle. The circle grew. It was irregular, imperfect. Now, without any effort, it had shaped into a spiral and I simply placed one stone after another in the unending thread.

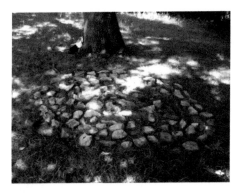

I carry one stone in each hand.

They are quite large, heavy.

I find one stone with a whole shell fossil. A beauty. I don't pick it up and move it – that one's for another time.

Citoyennes du Monde
Citoyens du Monde
Citizens of the World

The whole stone project – the whole caboodle!

## 7/8/15

Since my father died, I can no longer use language in the same way. It doesn't work.

It has lost its obedience to the rational world and needs to obey some deeper river.

I come to the spiral of stones. Sit down with my back against the trunk of an oak.

A feeling of relief.

The sky is brilliant blue, the yellow flowers the colour of free-range egg yolks.

A pigeon flaps around.

I am just back from London, re-ignited by the energy of that fabulous city.

Not a pigeon in the tree, but a squirrel.

I met a squirrel on the way here. We both stopped. It was in my way. I was in its way.

The tree squirrel barks at me.

Today, feathers.

1 x crow feather that I bring from the path to the spiral.

1 x small feather in the grass – grey/white.

1 x very small black feather, jet, crow/rook.

I took feathers to the scattering of my dad's ashes – 1 for each person present to take and release. I miscounted; there wasn't a feather for me. And now, here, in this field with these stones, 3 feathers appear.

I carry 2 stones at a time. One in each hand.

This is not fast work.

It is not slow work either.

It is work that finds its own pace, its own rhythm.

Something is being worked out, worked through.

It will take as long as it takes.

Having worried about the way the land dips on one side, I now love the way the spiral folds into this dip. It curves as the land curves, falls away as the land falls away.

It is almost impossible to say how I feel sitting here with these stones.

Last night, a young girl said to me 'You're mad'.

Today I want to say yes. I'm mad. We've waited for a long time to have a woman's madness in the world rather than having it locked away.

## 12/8/15. 10.30 ish.

I no longer care if the circle's a good circle or not.

It's just moving around in its own irregular way and that's fine.

It doesn't lessen or diminish the grief doing this – what it does is open up a mindless space. I'm just carrying stones. Sometimes thinking I really like the shape of this one or that one.

Today I enjoyed the juxtaposition of a big stone next to a little stone.

The company of stones.

Thinking about the difference between migration and moving. How one is so much more weighted than the other. Stones move in all different sorts of ways. They migrate in different ways too. Some migrations are forced, even brutal: I move stones, rocks are mined from the earth, they travel in the holds of ships as ballast. Other stones move of their own volition: erratics and the stones shaped like footballs in the Valley of the Moon in Argentina where archaeologists do not dig but wait for them to rise to the surface, their movements aided by rain and wind erosion of the soil.

So too, people move in different ways and for different reasons.

**5/9/15**

First time back after being away in Scotland.

A little nervous –

Two stones displaced.

A dog has pooed at the base of the oak.

Grasses growing between the stones.

The stones are still, the grasses move in the breeze.

The stones look like a blanket laid over the ground.

I realise it's a way of keeping dad's death close to me.

Staying close to the wound.

Remembering today a conversation I had with him about being a psychopomp – talking to the souls of the dead and helping them to usher over. Saying that this was my real work in the world, my real job.

He just listened. It wasn't really his thing but he gave lots of space to me to say what needed to be said.

He was good at that.

At letting you say whatever you needed to say.

He didn't disagree or try to fix things.

It was a gift he had.

I loved him for that.

Started off really cloudy but now the sun's out – shining on the circle and me and the oak tree.

\*

Stone's weight makes me reconsider.

Stone's shape, weight, texture makes me reconsider.

Stone's solidity, stone's pick-up-ability, stone's surrender makes me reconsider.

Stone's surface makes me reconsider.

Stone's silence makes me reconsider.

Stone's snuckle into the palm of my hand makes me reconsider.

Stone's situation makes me reconsider.

Stone's costume of moss makes me reconsider.

Stone's spangle of light makes me reconsider.

Stone's place in the cave of the roots of a tree makes me reconsider.

Stone's situation makes me reconsider.

Stone's relation to other stones makes me reconsider.

Stone's size makes me reconsider.

Stone's appeal makes me reconsider.

Stone's rootedness makes me reconsider.

Stone's call to me makes me reconsider.

Stone's gravity makes me reconsider.

Stone's willingness to come with me makes me reconsider.

Stones make me reconsider.

**10/9/15. 8.30 am.**

Mist today.

My favourite weather.

Pheasants clucking away.

The spiral has reached the tree. The oak tree's trunk is now included in the spiral of stones.

One day, I'd like to open the whole thing up so that people can walk through it.

It soothes me, the making of this.

It disturbs me too.

As if I'm making a clock. Using stones to count time. Each stone marks a minute or so more away from his death.

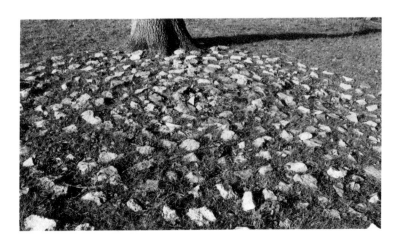

**A visit with no date, day, time, note.**

**Saturday 17/9/15. 9am. Mist.**

For the first time I insert a stone that isn't in sequence. All the previous stones have been put down one after the next, constantly increasing the size of the spiral. Today though I noticed a gap between a stone and an oak tree root that was too big for my liking. I then selected a small stone to bridge the gap.

This was my first revision.

I'm thinking less about what it is and I'm just doing today. Gloriously empty-headed apart from the few stray thoughts that come and go.

I don't know how big this spiral will get.

Perhaps days will come when I only move one stone.

I'd like to talk to the owner of the field about what I'm doing – then I can gauge what comes next.

Jim Carruth calls himself a rural poet. I could go with that. I am not an ecopoet and never have been. Rural is just fine though, a word that's dirtier, more honest.

I love working with stone.

The mist today isn't lifting.

Hanging and eerie.

**19/10/15**

Remembered walks: pilgrimage across Somerset to join up the graves of my grandmothers, like a dot to dot walk. First Nan Hallett's grave in Wembdon, then through Bridgwater, over the motorway to Chedzoy and Nanny Hooper's grave. I met Dad on the other side of Chedzoy by Parchey Bridge. We walked the length of King's Sedgemoor Drain together then had lunch with Aunty Jenny in Bawdrip. The three of us sitting on a bench in a graveyard eating sandwiches.

I carried on to Glastonbury alone. When I got there, Dad met me again and we walked the labyrinth at the front of St. John's Church together. Me, Dad and Pixie, his dog, going round and round until we got to the centre.

After Dad's cremation, I popped what looked like a plastic sweetie jar in my rucksack and walked around Bridgwater with his ashes on my back. We went to the house where he was born, along the river, through the park where he liked to walk his dog, up by the canal, over the River Parrett.

I liked the weight of him on my back. Our last walk together before the scattering.

**20/10/15**

When I see people coming along the path through the field I hide.

I stand behind the tree or stand very still and hope they don't see me.

Most people pass without glancing my way. They don't seem to notice the stone spiral either. Amazing how it can be just a few metres from the path and invisible at the same time.

## 21/10/15

Took Craig to the stones.

The spiral was disturbed – a lot of stones out of place – like a broken up jigsaw. Craig helped to put them back.

There are cows in the field. They are my new collaborators.

Craig added 2 stones.

Cows came and had a good sniff at the stones, grass, tree – very curious.

My worst fear – the stones being moved/displaced and actually it's fine – it makes the spiral feel alive – as if the place has its own life.

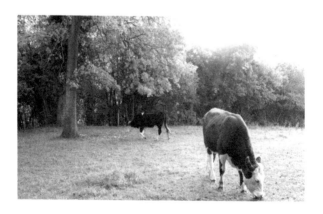

## 11/11/15

So long since I was last here.

There are big cow pats and more stones out of sync with the spiral. I started to move them back, to try to refind the shape that had been there – then thought why do that? What if a new and unknown shape is being made here? If I really think of the cows as involved in the work, then what they bring and what they add is surely part of it too?

In essence, a shape that I don't know, that I don't have a name for is coming into being.

## 13/11/15

I go back to the stones.

They look unremarkable.

Insignificant.

Overgrown with grass and weeds, and now a covering of fallen leaves.

As soon as I start working with them though, they draw me in. Something begins to happen. I work without thinking, adding a few stones to the spiral, then I stop and look and see that it's alive.

For a moment it makes me breathless. It seems to contain power, to be pulsing. I don't know how this happens.

The word I want to use for the circle/spiral is

                        potent

it feels potent, it does something to me as much as I do something to it. I'm not quite sure how that happens or where I go with it. For now, I'll keep on visiting and keep on working.

\*

What am I doing / with these stones?

I am describing the sun.

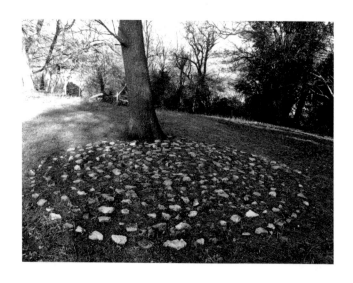

I'd like to finish this chapter with a poem by Jim Carruth from his book *Killochries*.

> *Jist open yir lugs*
> *an listen –*
>
> The old man's first advice
>
> In the wood, on the hill
> and up onto the muir;
>
> in the dawn and sunset,
> the birdsong and the breeze.
>
> I am listening.
> Shape me, make me new.

# Chapter 5

## Entering The Vastness

March 2017, Durgan Beach, Helford Passage, Cornwall. I lie down on a large rock and stare at the pebbly beach. There's something reassuring about pebbles. They possess themselves, inhabit the stoniness of stone and seem to be just what they are, no more, no less. In *Unfinished Ode to Mud*, the French poet Francis Ponge notes that a pebble is:

> still a few days of freedom from significance in any practical order of things. Let's see what it has to teach us.

A pebble changes shape as it rubs along with its companions or is tumbled in a wave. Its shape-shifting is slow, tiny, constant. Day after day, night after night, pebbles lie on the beach, as the beach, as individuals en masse. They seem to be looking at the sea, to be looking at the water, as if there's a tension between stones and water, the same kind of tension that exists between a piano string and a hammer. All potential held in that tension. And of course they submit to whatever comes; rain, wind, sea, the footsteps of humans, the sound of thunder.

I lie on a rock and stare at the beach. I love being horizontal, close to the earth. We spend so much time on the vertical plane, so much time standing on our two little feet. In the West, uprightness extends beyond simply standing up and enters a moral dimension that is considered good, necessary and an essential part of being civilised. Yet whenever we are standing, only a tiny proportion of our

bodies in is contact with the earth via the soles of our feet. What have we done to ourselves by spending so much time being upright? By diminishing our contact with the earth?

I stare at the pebbles. They are continually in place, of place, and making place. Free from significance in the practical order of things. In the heart of their apparent inactivity is a wealth of creation where being wholly what they are, and only what they are, is a way of making something happen by not making anything happen. This echoes lines from the *Tao Te Ching* by Lao Tzu, translated here by Ursula K. Le Guin:

> The Way never does anything
> and everything gets done.
> If those in power could hold to the Way
> the ten thousand things
> would look after themselves.

By not doing anything, everything gets done. Beach is beach is beach.

I lie on the rock on the beach, stare at the pebbles and nothing happens. The rock carries on being rock and after a while a feeling creeps into me. It spreads throughout my body. Infects me. The beach pours in through my ears, my eyes, my skin until I become as inert, as useless as a pebble.

These pebbles are hundreds of millions of years old. They are my past. My future. My present. My material reality. One of my favourite Brazilian writers, Clarice Lispector, says:

> I want the material of things. Humanity is drenched with humanisation, as if that were necessary; and that false humanisation trips up man and trips up his humanity. A thing exists that is fuller, deeper, deeper, less good, less bad, less pretty.

I am on the beach, of the beach and making the beach. All things at once, no separation between us. It's like being at a school where I have a million teachers who are all teaching me at the same time by doing nothing.

The old bards used to lie down with a stone on their bellies before they wrote. Poet and stone. Stone and poet. And who knows who was talking to who and who was listening. Intimacy dissolves boundaries, but it's hard to discuss equality with things in a language that's predicated upon subject, verb and object. As a way of questioning this, the physicist David Bohm suggests that:

> ...instead of saying, 'an observer looks at an object', we can more appropriately say, 'observation is going on in an undivided movement involving those abstractions customarily called "the human being" and "the object he is looking at"'.

The 'undivided movement' feels more honest, more real, closer to my experience. Being undivided leads to a space where there is no distinction between observer and observed, subject and object. Instead, there's undivided movement between all things, an ongoing process of exchange. The flesh of my body mingles with a body of rock: we come into contact and whatever we are in that moment, whatever happens, is created by and because of both of our existences.

This is what the pebbles give me, a chance to be quietly revolutionary, to abandon the first fifty-two levels of being human and drop down into something else. In *The Living Mountain*, Nan Shepherd writes:

> So, simply to look on anything, such as a mountain, with the love that penetrates to its essence, is to

widen the domain of being in the vastness of non-being. Man has no other reason for his existence.

We are so small, and yet the things we feel are so huge. If we look with love, we experience the coming together of being and non-being and in this way we enter the vastness.

I'd like to finish this chapter with a poem by Charles Simic.

### Stone

Go inside a stone
That would be my way.
Let somebody else become a dove
Or gnash with a tiger's tooth.
I am happy to be a stone.

From the outside the stone is a riddle:
No one knows how to answer it.
Yet within, it must be cool and quiet
Even though a cow steps on it full weight,
Even though a child throws it in a river,
The stone sinks, slow, unperturbed
To the river bottom
Where the fishes come to knock on it
And listen.

I have seen sparks fly out
When two stones are rubbed.
So perhaps it is not dark inside after all;
Perhaps there is a moon shining
From somewhere, as though behind a hill –
Just enough light to make out
The strange writings, the star charts
On the inner walls.

# Conclusion

When you came into the Great Hall at Dartington today, you will have found a small pile of pebbles sitting on the table in front of you. I began collecting these months ago, when Richard Povall first invited me to give this talk. I wanted to begin gathering, wanted to start enacting the talk in the world, to use my body as a way of speaking that would never be heard.

I gathered the pebbles from three different places: Swanpool Beach in Cornwall; Widemouth Beach, North Devon; Chesil Beach, Dorset. Each time I picked up a pebble, I thought of you, the people who would one day gather in this hall. I thought of you and I picked up a pebble and made a little imaginative bridge between us.

I drove the stones home in my car then put them outside on my balcony. They huddled together beneath a daphne plant that came from my nan's garden in Bridgwater. Ten days ago, I began moving them around. Into lines at first, then into a circle.

I collaborate with stones. With friends. With letter carvers. During the writing of this talk I walked barefoot through a meadow behind my house at least three times a day with two dogs. I collaborated with daisies, dandelions, the first wild orchid of June.

To bring the stones to Dartington, I searched my flat for something to wrap them in and stumbled across a pair of bright pink, hand-knitted slippers that were sent to me by my friend Edit Pulaj, an Albanian artist. These slippers were part of *Pink Partisans*, a project raising awareness of equal rights

for gay, lesbian and transgender people in Albania. The stones fitted into them perfectly.

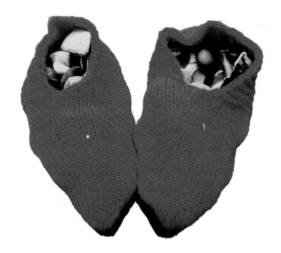

There's a little echo, too, of the performance artist Marina Abramović's shoes for departure – shoes that were carved out of amethyst. Only this time the stones have slippers as they prepare to migrate from my flat in Somerset to Dartington.

Perhaps we can enter a quiet space now for a moment or two. You, me and the stones. Perhaps you'd like to choose one and hold it. Hold it in your hand, close your eyes if you're comfortable with that. And then we can breathe. Just breathe with the pebbles and the vast space of this old hall. Breathe and be aware of the limestone beneath the foundations of this building, and of the rocks and stones above our heads, orbiting in the sky. For three minutes, let's breathe together with our stones.

I'd like to finish with a poem I wrote after spending time in Gjirokastra, a city known as *the city of stones*.

**?**

what possesses a stone
picked up on a road
in Gjirokastra

what makes it
the one and only
stone

I've got to
pick up
and take home
of all the
thousands of millions
of trillions of

stones in the world
what makes
this one

the one
I want
without question

# Bibliography

Bohm, David (2000) *Wholeness and the Implicate Order*. Routledge

Borges, Jorge Luis (2000) *This Craft of Verse*. Harvard University Press

Carruth, Jim (2015) *Killochries*. Freight Books

Cixous, Hélène (1992) *'Coming To Writing' And Other Essays*, (ed. Jenson, D) (trns. Cornell, S. & Jenson, D. & Liddle, A. & Sellers, S.). Harvard University Press

Esquinca, Jorge (2004) *Región*. Universidad Nacional Autonoma De México

Hallett, Alyson (2007) *The Stone Library*. Peterloo Poets

____ (2013) *Suddenly Everything*. Poetry Salzburg

Ingold, Tim (2011) *Being Alive*. Routledge

Kadare, Ismail (2011) *Chronicle in Stone*. Canongate.

Lao Tzu (1997) *Tao Te Ching* (trns. Ursula K. Le Guin). Shambhala Publications

Lawrence, D.H. (1990) *The Plumed Serpent*. Penguin Books

Leonard, Tom (1995) *Intimate Voices*. Vintage

Lippard, Lucy (1995) *Overlay*. The New Press

Lispector, Clarice (2014) *The Passion According to G.H.* (trns. Idra Novey). Penguin Classics

Mauss, Marcel (2000) *The Gift*. W.W. Norton & Company

Nin, Anaïs (1980) *The Diary of Anais Nin 1944-1947* (Vol IV). Harcourt

Ponge, Francis (2008) *Unfinished Ode to Mud*, (trns. Beverley Bie Brahic). CB Editions

Sebald, W.G. (2007) *The Emergence of Memory*. Seven Stories Press

Shepherd, Nan (2008) *The Living Mountain*. Canongate

Silko, Leslie Marmon (1996) *Yellow Woman and a Beauty of the Spirit*. Simon & Schuster

Simic, Charles (2004) *Selected Poems*. Faber and Faber

# Notes from the Deleted Pile

*The following sections were removed from the talk because of time constraints. I have included them here as a way of expanding some of the threads and including the excluded. A little treat for the curious.*

## 1. The Body

I told you at the beginning that I'd be following my body. That we'd be on the trail of stones and love, that this would lead us where we need to go. And I believe it will. But we have to come via this place to get there. I need to talk about the body as a site of intelligence, the body as a place, an environment, a landscape. The body as a wilderness, a wild place, a tamed place, a known and unknown place. A place where relationships are always evolving and changing, where there is a fixed and fragile frame known as skeleton. The body as a site of distress, of memory, of perception. The body as a position, a place of witness and action. The body as beginning and end, receptive and active, the body as transmitter and receiver, as a place where everything happens. The body is our home, our host, the first house of being. This body, my body, born from my mother's body and which contains minerals and elements of the bigger body, the Earth, carbon, calcium, titanium.

## 2. Translation

> We want to have ourselves translated into stone and plant, we want to go for a walk in ourselves when we wander in these halls and gardens.
> Nietzsche, *The Gay Science*

Translate me into stone. Translate this body, this mind, these hands and feet. Translate my veins. Translate my lungs, the air in my lungs, the hair on my head into stone. I want to walk in myself, in the landscape of me. Once, an old tree in Hartland Vale showed me how to do this. Once, it was an oak that translated me. Who will translate me into stone? In the end, that's all I will be. A translation into stone and plant. Literally. Unhoused from this envelope of skin and folded into grass, into daisies, into limestone, slate or granite. For now, translator, be kind, be gentle. Translate me then show me the way back.

## 3. Indigenous

I am indigenous to Somerset; I consider my indigeneity to be in recovery. It has been a long time overlooked. The Somerset accent has been a long time associated with stupidity, a stalk of straw in the mouth. In my first weeks at university, people laughed at the way I spoke. Tom Leonard says that your voice lets people know whether or not your education was paid for. Well, my education was comprehensively free. But those months at university were hard. Somerset was stitched into my tongue. The Mendips, the Quantocks, the Levels, the rhynes, a whole ancestry stitched into me and the way I spoke.

Piece by piece, I removed the land from my voice. I forked my tongue. I became a chameleon. The voice you hear today is not the one I grew up with. This is my grown-up voice. My survive-in-the-world voice. The voice I made when I chose not to go and work in a factory but to study books, to enter the kaleidoscopic heaven of a university. In me, in my body, in the landscape of myself, there is contested territory. To resituate my indigenous self is a work in progress, a difficulty, an ongoing task.

Have I ever abandoned the intelligence of my body? Yes. Have I turned away from what it tries to say? Yes. Have I sometimes gone against my grain? Yes, yes, yes.

## 4. Here

So when I see myself in the world, I see that I am part of it, that I am in relationship, that we are mutually dependent. Just as I would see myself with a friend, I see bonds and ties extend between us, I see that we are inextricably linked and that this linking is what gives me my life. It is the air I breathe, the ground I walk on, the water I drink, the fire that keeps me warm. Without these things, I have no body, no life, no existence.

In this way, a stone's life is as important as my own. Just as we are drawn to different places to live and be, and to different people with whom we spend our time, so too we are drawn to different elements. For me, it's stone that draws me – stones and rocks, perceived to be the least responsive, the least animate of things on Earth. But these things are the Earth – without them this planet could not exist. And if the planet doesn't exist, then I don't exist either. In this sense, the rocks and stones are the most important, the most significant companions. They give me life and somewhere to live my life.

Stones give me here, HERE, a sense of hereness – they are like a plunge into the world itself. Hold a stone and you hold thirty, forty, fifty million years in the palm of your hand.

## 5. Yield

I didn't realise this at the time. At the time I submitted, yielded to the experience of doing nothing, of being there unremarkably. Passive, quiet, surrendered. And the pebbles on the beach drew this out of me. Or let me in to them to see these possibilities. It was a collaboration. I was in a place that was being made minute by minute, second by second, by sea, rock, air. I entered into this with my walking and breathing and I laid myself down, I gave in to the horizontal, and stretched my body across a rock.

## 6. Charge

What interests me in any work with stones, is the charge that is able to enter them. What do I mean by this? I mean that there is a store of energy in the stone, a store that is created by me and the stone working together.

I make rituals for all of the stones that I work with. Each migrating stone – and there are five now – in England, Scotland, the USA and Australia – has been washed in water at the Chalice Well Peace Garden, Glastonbury. I take the stone there and wash it, or if it's too big, I bring water to the stone.

After words have been carved into the migrating stone by letter carver Alec Peever, I invite friends over. My friends are healers, writers, artists. I build a fire. I invite everyone to touch or hold the stone, to pass it around, to infuse it, to perfume it with good wishes, healing energy, migrating thoughts.

We then drink and feast together. This is the important work. The work that means all of my journeys with stones are conducted in a space that has been intentionally charged, made sacred. This means that when I'm working with migrating stones, when I'm undertaking a journey, I can be, for the most part, thoughtless. If anything happens, and particularly if something appears to go wrong, I suspend judgement and see it as part of the work.

This includes the stone I took to Los Angeles in 2016. It was lost in Iceland for three days. I changed planes in Reykjavik and somewhere along the way the airline lost my suitcase. The migrating stone was safely packed away in the case. For three days after arriving in LA I didn't know where the stone was. And the funny thing is that several months before, a

friend had suggested I should take a migrating stone to Iceland at some point...

It also includes a meeting with an Iranian refugee in George Square, Glasgow when I was taking the fourth migrating stone to Iona. My friend Fiona, who was helping me with the stone's migration, asked a stranger to take our photo with the stone which was nestled inside a big wooden box. The man took the photo then asked what we were up to. I told him about the project. He then began to tell us his own story of migration and how he had been tortured and kept prisoner for years in Iran. He showed us his hands. He had no fingernails. This was the first time he had spoken of what had happened to him since arriving in Scotland. He told us he had had a very good friend who was a sculptor. I asked if he wanted to see the stone. He said yes. And so in the middle of George Square, in the middle of the day, I opened the box, peeled back the layers of bubble wrap and revealed the fourth migrating stone. The man knelt down, put his hands on it and wept.

## Transparencies

Rocks offer their faces
to the wind and sea.

They want to be eaten, eroded,
want the inner substance
to be brought to the surface.

One day these rocks will be sand
and that sand food for a furnace.

This is how glass is made,
how the densest material
becomes transparent.

It's the same with the darkest
parts of our souls.

They want to offer themselves
to the elements, to the weathers
of being human.

I'm talking about breaking things down.
About transformation.

How things
that are too heavy to carry
can change and lighten.

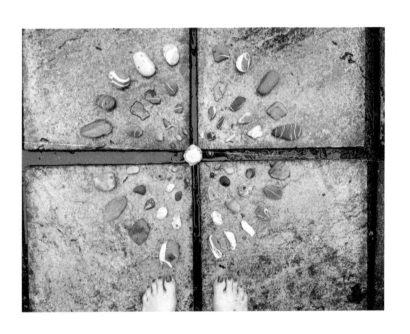

# Acknowledgements

I would like to thank Richard Povall for inviting me to deliver this talk at the 'In Other Tongues' symposium. I would like to thank all the fellow contributors and participants for their lively attention, conversations, collaborations and explorations. Thanks to Craig Besant for help with taking photos of the stone circle/spiral in Somerset. Thanks to Mat Osmond for his support and encouragement. Thanks to everyone who helps with the migrating stone project – for believing in this work, for joining in, for being part of an unregulated stone clan who approaches stones with love and awe. Thanks to Grace and Fig for walking with me each day when I was writing the talk. Thanks to Arts Council England for taking a chance on a proposal to research and respond to migrating stones – thanks for the funding I have received and to everyone who has supported this project. Thanks to Poetry Salzburg for kind permission to reprint poems from *Suddenly Everything*. Special thanks to Alec Peever. Thanks to Charles Simic and Faber and Faber Ltd. for permission to reproduce the poem 'Stone' from his book *Selected Poems*. Thanks also to Jim Carruth for his generosity in allowing a poem from his book *Killochries* to be reproduced here free of charge. Special thanks to the stones that accompany me on all my journeys: thanks for their existence, for leaping into my dreams, for being constant companions and sources of mystery and inspiration.

# Haunted Landscapes

A version of this talk was first given at the 'Haunted Landscapes Symposium', Falmouth University, 2014. It is included in this book as a companion piece, so that the talks have each other for company.

Once upon a time I was born. I was a foetus who became a baby. I came into the world, opened my mouth and breathed. The water was gone. The sea around me had disappeared. Suddenly everything was bright and loud and dry. My body uncurled. The cord was cut. I thought I had died. I cried. And then, as I acclimatised, I realised they were still with me. The ones who kept me company on the other side. The ones who would keep me company all my life.

Eighteen years later my mother told me that she miscarried five boys before I was born. She had called them all Julian. If I had been a boy I would have been called Julian too. But I wasn't a boy. I was a non-boy. A girl who was called Alyson. Finally, then, when I was eighteen I was able to think: so that's who they are. The ones who have kept me company. They are my brothers. I have known them all this time. Not as I know other people who breathe air and live in bodies. But as presences who are invisible and not restrained by the limits of skin and limbs: who can be anywhere and everywhere at any time they wish.

This paper is a musing upon haunted landscapes. I'll be wondering about the body as a landscape that haunts and is haunted, and I'll be musing upon the living and the dead and whether we really know the difference between the two. To help me do this, I will draw upon ancient Chinese thinkers, quantum physicists and poets. I have more questions than answers and intend to create a space where we can explore misty places, places where we might no longer be longer sure of ourselves or anything else. As Clarice Lispector writes, "I need the courage to use an unprotected heart and keep talking to the nothing and the no one as a child thinks about the nothing."

I'd like to start by asking: who's haunting who?

I have to say that I have no idea how to answer this question, but I think it might be an important one. I'd like to approach it by talking about the experience of the 4th century BC philosopher Chuang Tsu. Chuang Tsu once had a dream. In this dream he dreamed he was a butterfly. When he woke up though, he was no longer certain about who was doing the dreaming, and who was being dreamed about. This lack of certainty made him ask the following question: "Now, how can I tell whether I was a man who dreamt that he was a butterfly, or whether I am a butterfly who dreams that she is a man?" This question points to an important idea in Taoist thinking, namely that of interfusion. I will come back to interfusion later. For now, I'd like to marvel at the mind that is capable of turning something upside down by entertaining the idea that a man may be a figment of a butterfly's dream. In the same way, we might want to ask whether we are going to talk about landscapes that are haunted, or hauntings that are landscaped. I'm going to reflect upon this and hopefully bring us a little closer to what Hélène Cixous calls "disturbing strangeness".

What is a landscape? We, the creatures of the light, live briefly on the surface. Whereas the dead, those who have gone before us, are sunken down; they are the deep to our shallows. In time they sink so far they become rock and stone. Not only our ancestors, but all other animals and creatures that have gone before us. Everywhere we go we are walking on everything and everyone who has gone before. We build our buildings on the bodies, the bones, the blood of our relatives. The Native American Chief Plenty Coups of the Crow tribe said: "The ground on which we stand is sacred ground. It is the blood of our ancestors." I wonder how often we think of this when we're running from the refectory to the lecture theatre, when we're walking from our front doors to the train station. Not a landscape, but sacred ground. The

blood of grandmothers and grandfathers, brothers and sisters, lovers, in the earth beneath our feet.

In 'How To Love The Dead', a poem by Jack Gilbert, he writes the following,

> She lives, the bird says, and means nothing
> silly. She is dead and available,

He goes on to suggest that he can love and desire the dead with his wolf heart. This isn't a polite, delicate love, but one that's feral and raw. It's not an easy thing to do – rather it brings you into contact with the "painful love of being/ permanently unhoused."

It's not only the ground that's full of our ancestors. This air we're breathing, it's the same air that's been here since time began. This water we're drinking is the same water that's been here forever too. It all just goes round and round, being recycled, transforming from one second to the next. How many people have breathed this air before us? How many have drunk this water before me? How many are unhoused, as Gilbert says, permanently unhoused, without bodies, as fluid as water, as mercurial as air? What is this landscape where haunting happens? Is it an airscape too? A waterscape? Gilbert tells us that it's not the woods or fields, not the cities, but something far less tangible, an unhoused place, a place that cannot be fixed or spoken of as a complete thing.

How do we talk about intangibles though? How do we start to think about them? The quantum physicist David Bohm argued that our object-oriented, noun-based language caused us to see a world filled with static objects rather than a series of dynamic processes. In his book, *Wholeness and the Implicate Order*, he suggests that there is in fact an ongoing and mutual relationship between all things.

If we bring this way of seeing into the domain of our own investigations, we might want to consider an undivided movement between the haunting and the landscape. Of course if we do this and the movement really is undivided, then it is no longer possible to be talking about hauntings and landscapes because they have become inseparable processes.

A sentence suggests there is an order to things, a way of being and speaking that effectively fixes things in place. But what if the order of things is not quite so ordered as we once imagined? Another physicist, Niels Bohr, addressed this problem with language by contradicting himself whenever he gave a lecture. He would say one thing and then immediately say the opposite. He did this as a way of destabilising not only language but how we see the world. He didn't want certainty: he wanted fluidity. He resisted the safe haven of authoritative knowing and instead opted for giving his students an experience of flux by opening up spaces that didn't make sense in a conventional manner. Which was what he needed to do, because his encounters with quantum physics showed him that conventions no longer applied. Normality was no longer normal.

If I were to experiment with Bohr's example, I might say "I am alive". Then, "I am dead". Then I would ask the following question: "if I am living, does this mean that the dead are dying?" And if that's the case, "how do we now understand the difference between being alive and being dead, being here and being elsewhere, being haunted or being the ones who haunt?" Questions like this make me nervous. They upset me. They take me away from anything I think I know and set me afloat on a fathomless sea. It's the instability that all poets conceive of. It's the negative capability that Keats speaks of when he argues that instead of clinging to reason, we need to live in uncertainties, mysteries, doubts without

"any irritable reaching after fact and reason". It's what Chuang Tsu was doing all those years ago when he asked the question, am I a man dreaming he's a butterfly, or a butterfly dreaming she's a man. It's asking for a fluidity of perception such as we see in this passage from a book called *Ill Seen Ill Said*, by Samuel Beckett:

> But she can be gone at any time. From one moment of the year to the next suddenly no longer there. No longer anywhere to be seen. Nor by the eye of flesh nor by the other. Then as suddenly there again. Long after. So on. Any other would renounce. Avow, No one. No one any more. Any other than this other. In wait for her to reappear. In order to resume. Resume the – what is the word? What the wrong word?

Beckett is perhaps one of the few writers who would suggest looking for the wrong word. As if the wrong word might be the right word. And so this is the point where poetry and physics meet, where the quantum fluxing universe finds expression in language that resists being settled or straightforward. Which in turn prevents us from anaesthetising the world, making it too safe or too known.

Another poet who ventures into the territory of disrupting what we think we might know about being dead and alive is the sixteenth century Persian poet Jalal al-Din Rumi. In the poem 'Wean Yourself' he asks an unborn embryo to imagine the world that exists outside of the womb. He says:

> The world outside is vast and intricate.
> There are wheatfields and mountain passes,
> and orchards in bloom.
> At night there are millions of galaxies, and in sunlight
> the beauty of friends dancing at a wedding.

Rumi then asks the embryo why he or she stays cooped up in the dark. This is a metaphorical way of asking each one of us why we stay cooped up in our vision of life and the world, why we might prefer restrictions to the potential vastness. The foetus answers his question by saying:

> There is no "other world"
> I only know what I have experienced.
> You must be hallucinating.

The foetus is not being unreasonable. He or she is saying what most of us would say. After all, when you live curled up in a red room that fits you the way a glove fits a hand, how can you possibly conceive of a place that's filled with air instead of water, and where there are wheatfields and mountain passes? How preposterous! How unthinkable!

Thinking about haunted landscapes, then, is an opportunity for us to get together and hallucinate. About living and dying, haunting and being haunted, landscapes and landscapings. Everything in a state of hallucinatory transformation because it's all transition in the beginning and in the end, it's all movement, it's all about shifting from one thing to another – and these evolutions apply to the living and the dead, the animate and the inanimate, they apply to everything. We are alive and thus living. The others are dead and thus dying. But what do they do with their dying? Do they have action plans and goals and holidays? They possibly do what we call haunt, they possibly do many other things too. And some of those other things might be accessed by writing.

Margaret Atwood, the Canadian author, refers to the process of writing as negotiating with the dead. She says,

*...all* writing of the narrative kind, and perhaps all writing, is motivated, deep down, by a fear of and a fascination with mortality – by a desire to make the risky trip to the Underworld, and to bring something or someone back from the dead.

You may find the subject a little peculiar. It is a little peculiar. Writing itself is a little peculiar.

Writers too are probably a bit peculiar as we spend our days travelling to and from the Underworld searching for something we don't know we're looking for. Atwood goes on to make a useful claim about writers though, when she suggests that all writers are in fact two people in one. There's the one who goes shopping, pays the bills, perhaps meets a friend for coffee. And then there's the other one. The one who's away time-travelling, who's so utterly gone into another place, so absorbed, that all conventional notions of how the world is structured and arranged completely disappear. I can vouch for this. When I'm writing, I am wholly elsewhere. In a state of flow, or absorption, a place where there is no time. And if there's no time, there's no concept of past or present, alive or dead. Instead, everything is in a process of being born: the people, the landscape, aliveness, deadness, all in the hub of the undivided movement that the physicists talk about. With writing, a world and everything in it is being made as the pen or pencil moves across the paper. At this point, the contradiction becomes a paradox. The fictional character is real. The past is the future. I am alive and dead. The only thing I don't think about when I'm writing is how to understand any of these things. That's left to the non-writing part of me, the one that goes shopping and cooks and values all things linear and rational.

The poet e e cummings says that if anyone wants to follow a creative path they need to leave the universe that's full of

doing and measurements, and instead come into what he calls "the immeasurable house of being". Rimbaud, also a poet, counselled the need to unlearn many of the things we have learned if we want to really experience this world in all its rawness and fullness. He called this process "deschooling the senses". By this he means getting rid of the politenesses and manners that we have been burdened with (as Gilbert mentioned earlier). He means peeling back the conventions. Crossing boundaries. Being elemental, as D.H. Lawrence expressed it, rather than being "lop-sided on the side of the angels". It's not the path for everyone. But if we're really interested in hauntings and landscapes, I suggest it might be necessary to first unlimit ourselves of the things we think we know so that a different space can open up. The poet Hélène Cixous writes,

> What a blessing! My littleness, what luck! Not knowing the limit! Being in touch with the more-than-me! Gives me the strength to want all the mysteries, to love them, to love the threat in them, the disturbing strangeness.

Here we are then, in the swirling heart of paradox. Let's imagine that landscaping and haunting are happening now, in this room in different ways for each one of us in an undivided movement. We might need to hold on to the edges of our seats, or we might run open armed into this disturbing strangeness, the one we don't know and can't control, the instability at the core of things, the shuffling of language until it becomes pliable enough for us to conceive of another way of being.

I'm going to read one of my poems now. It's called 'Walking With The Dead' and is based upon a walk I used to do near an abbey in the village of Hartland in North Devon.

## Walking With The Dead

*[the dead and the dying] aren't really gone, they just hover
somewhere at the perimeter of our lives and keep coming
in on brief visits.*
W.G. Sebald, *The Emergence of Memory*

To walk where monks once would have walked,
to step where they too have stepped,
to press these lips to the same sea salted air,
to taste on a breeze lost fevers of their talk.

To be with them is everywhere and nowhere.
Spinnakered against the wind like a blade of grass,
like a tree upshooting and rooting –
a dot on a curve of a very long line.

To be with them is to step out of time,
to unsign the treaty that binds us to past, present, future –
a dot on a curve of a very long line,
that line a circle: fecund, sublime.

You see, I do not believe in the otherness of the dead.
In my heart there is a green light shining.

Finally, I'd like to limit the limitlessness by talking about
interfusion. This idea arises from Taoist philosophy and
introduces us to the idea of being neither one thing nor the
other, but in a continual state of movement and negotiation
between the two. I am not so much a human being on a
planet, as a planet-infused human being. Interfusion seeks to
define an experience of life that is concerned with wholeness.
Chung-yuan writes:

> In this unity everything breaks through the shell of
> itself and interfuses with every other thing. Each
> identifies with every other. The one is many and
> the many is one. Each individual merges into every
> other individual.

For a moment, then, let's become the haunted landscape. Let's shed the appearance of separateness and merge instead. Let's leave behind the stability of being able to name things, let's enter the disturbing strangeness together. This is the immeasurable house of being that I enter when I write, it's the peculiar terrain that Atwood referred to, a place where time unhinges and we are plunged into that swirl of energy where we listen to the voices that can't be heard and write them down.

In the end, then, I offer my body, my being, as a haunted landscape. Not a wood, or an old house or a battlefield, but my body. I carry the dead with me, just as they carry me. I offer my five, miscarried brothers. I offer my written words, my spoken words, this air, this earth, this moment. It's not easy to talk of these things. I rarely talk of these things. But here I am, talking. Here I am, talking from what the Japanese Butoh dancers call a frog's eye view. I'm talking to you from the mud. From the earth. From the place we haunt and are haunted by.

Thank you.

# Bibliography

Atwood, M. (2003) *Negotiating With The Dead*. Virago Press.

Beckett, Samuel (1997) *Ill Seen, Ill Said*. John Calder

Bohm, David (2000) *Wholeness and the Implicate Order*. Routledge

Chung-yuan, C. (1975) *Creativity and Taoism*. Wildwood House

cummings, e.e. (1974) *i six nonlectures*. Harvard University Press

Cixous, Hélène (1992) *'Coming To Writing' And Other Essays*, (ed. Jenson, D) (trns. Cornell, S. & Jenson, D. & Liddle, A. & Sellers, S.). Harvard University Press

Feng, Gia-Fu and English, Jane (trns.), (1974) *Chuang Tsu Inner Chapters*. Alfred A. Knopf

Gilbert, Jack (2001) *The Great Fires*. Alfred A. Knopf

Lispector, Clarice (2014) *The Passion According to G.H.* (trns. Idra Novey). Penguin Classics

Rumi, Jalal al-Din Maulana (1995) *The Essential Rumi* (trns. Barks, C. with Moyne, J.) Harper

# The Stone Monologues

**1**

The quest is to understand myself not as a single thing, a single point, but rather a constellation, a layered interruption in time comprising everyone and everything I encounter.

**2**

When I said I wanted to leave home my mother wept. I have never seen such a storm on the mountain and I feared she would not let me go. The tears she cried froze around me and I was swaddled in ice for a thousand years.

*Saddled in pure white, I rode the back of the Earth until sun turned my horse into water.*

It broke my mother's heart to see me leave and that breaking made my journey possible.

**3**

When I arrived in the foreign land I knew no-one. All I had to offer were songs and stories from my mother-land. For a long time the people around me could not understand what I was saying. They thought their world and their ways were the only ones and feared I might want to change them.

*Exchange, I said, that is what I want.*

**4**

Everything I have come to understand as being
one way is no longer that way. The straight line
becomes a curve, the contradiction becomes
coherent, poverty becomes wealth. This is the
great law of reversal my ancestors spoke of. It is
essentially expansive, essentially ignorant of
boundary, essentially counter to almost
everything we have come to believe.

Why, under reversal's banner even God has
descended from a heaven in the sky to live as a
worm in the earth.

**5**

One day men came. They dug metal stakes into the
ground around me and joined them with a rope.

*But the rope that separates is the rope that joins.*

Particles of myself ride the wind into homes and
hands of strangers. Rain washes me into the earth
and the earth's fast running rivers. I record the
touch of a hand, step of fly, scud of clouds. I have
small pockets that catch words from a walker's
lips, light from the moon's bright lyre.

**6**

No one thing immediately changes into another. A
million steps are taken before you reach the place
where one more step takes you across the border.

**7**

Edges change day by day by day. The wall falls
down. The gate opens. The ocean eats the coast
and the volcano spawns a new island.

Negotiations of form are endless.

**8**

We learn to be patient as stars. We sit in silence
for the coming and going of many suns. We speak
when we were moved and there is no need for
translation: instead a direct transfusion of
meaning passes between us.

Crow, cloud, thunder.

In this way we share truths we did not know we
knew but were set upon this orbiting planet to
discover.

**9**

I remember the land and the land remembers me.
Together we make memory. My heart lights up at
the sight of so many friends who greet me along
the way.

**10**

I am not the first stone to speak and I will not be
the last.

# About the Author

Alyson Hallett grew up in Street, Somerset. She has an MA in Creative Writing from Bath Spa University and a practice-based PhD in poetry and geographical intimacy from St Mary's University, Twickenham. She has published more than 14 books: sole-authored collections of poetry, short stories, artists' books, *Six Days in Iceland* in collaboration with geographer Chris Caseldine and *walking limping stumbling falling* with walking artist Phil Smith. Her latest book, *LZRD: Poems from the Lizard Peninsula*, is co-authored with Penelope Shuttle and her recent pamphlet, *Toots*, was shortlisted for the Michael Marks and Callum Macdonald Memorial Awards. She has written an essay on chalk for Radio 3 and drama and an audio diary for Radio 4.

Collaboration is at the heart of Alyson's work. She has worked with dancers, musicians, visual artists and glass makers and received grants from Arts Council England. Her work with sculptor and letter carver Alec Peever has spanned two decades and includes a poem carved into Milsom Street pavement in Bath, poems carved into boulders on a housing estate in Kew, and the 5 migrating stones that make up the Migrations Habits of Stones international poetry and public art project.

Alyson was the country's first poet to be resident in a university Geography Department with a Leverhulme artist-in-residence award. She has been a poet-in-residence at Charles Causley's house and the Small School, Hartland; writer-in-residence for the Arts Council's Year of the Artist and the Endelienta Trust.

Alyson is a visiting lecturer in poetry at the University of the West of England and on the MA Illustration in Falmouth. She also works part-time for the Royal Literary Fund as a Reading Round Lector. Ongoing collaborative work with movement artist Deborah Black involves an exploration of embodied writing and how the body and the written word come together and inform each other.

Early in her career Alyson attended a summer school run by the performance group Goat Island. This, along with working as a housekeeper for the Iona Community on the Isle of Iona for a year and a half, blew her mind and heart wide open and formed the foundations from which she works and lives. Alyson has also worked as a post woman, bar person, cleaner and mental health worker. She lives in a village near Bath, loves to walk and play piano and is a Hawthornden Fellow.

www.thestonelibrary.com

# About the Publisher

Triarchy Press is a small independent publisher of books that could be seen as distinguished erratics if you were looking for a regular literary geology.

As well as Alyson Hallett's co-authored book *walking limping stumbling falling* and her co-edited poetry collection *Project Boast,* Triarchy has also published a number of books by Phil Smith about mythogeography, walking and counter-tourism; other books on the art of walking by Roy Bayfield, Ernesto Pujol, Clare Qualmann and Claire Hind; books about movement and somatics by Sandra Reeve and colleagues; poetry by Mary Booker and Julian Wolfreys; Nora Bateson's wonderful *Small Arcs of Larger Circles*; a book of erotobotany called *Arranged by Flowers*; and Robert Golden's narrative poem about exile and displacement – *Windows Kiss the Shadows of the Passing Thirty Million.*

www.triarchypress.net